Perspective

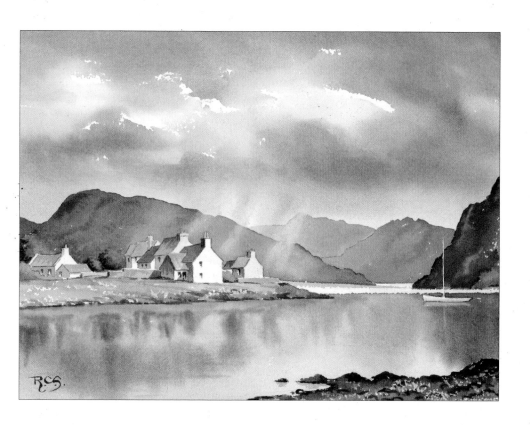

To my family, my friends and fellow painters,
and all who share my love of art.

Perspective

RAY CAMPBELL SMITH

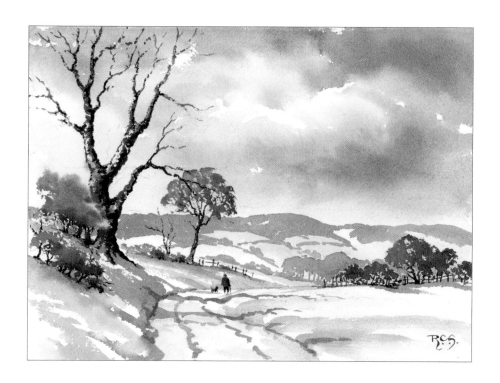

SEARCH PRESS

The publishers would like to thank Winsor & Newton for
supplying many of the materials used in this book.

Suppliers
If you have difficulty in obtaining any of the materials and
equipment mentioned in this book, then please visit the
Search Press website for details of suppliers:
www.searchpress.com

*I should like to acknowledge the invaluable professional
help I have received from Roz Dace, Editorial Director,
and John Dalton, Editor. I also wish to thank
Gillie Simon, M.B.E., for her expert help in arranging
and typing the text.*

Plockton, Wester Ross *(page 1)*
380 x 285mm (15 x 11¼in)

The North Downs, Winter *(page 3)*
380 x 280mm (15 x 11in)

Rye Church
380 x 280mm (15 x 11in)

Printed in Malaysia

Contents

Introduction

However brilliant the brushwork and the use of colour, a painting will never succeed if the underlying draughtsmanship is flawed. Faulty perspective is an insurmountable bar to excellence and in this book I tackle this problem head on. Many aspiring artists have problems with perspective, sometimes because of the geometric constructions involved. However, the geometry is very simple, and I will show you how everything falls into place once you understand the basic principle.

The laws of perspective show us how to represent a three-dimensional world on a two-dimensional plane. Before the Middle Ages, artists relied on observation alone and the perspective in many early paintings is eccentric to say the least. It was not until the Renaissance that the problem was considered more scientifically, when an architect named Brunelleschi discovered and codified the constructions with which artists today are familiar.

Those with scant knowledge of perspective often have little trouble depicting the natural world and get by on observation alone. Problems arise when they tackle man-made objects such as buildings – for with geometric shapes, any faults become glaringly obvious.

Old Broadstairs
380 x 290mm (15 x 11½in)
It is important to work out where your eye level line is before you start painting a subject such as this (see opposite).

Basic perspective

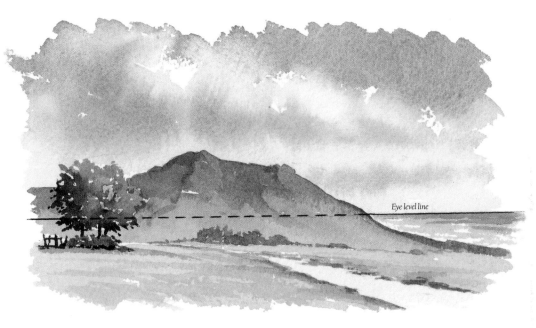

Here, the stretch of sea indicates the position of our eye level line. Without it we have to gauge where a horizontal line from our eyes to the hills would meet the hills (shown by the dotted line).

The first thing we have to understand is the exact meaning of the word horizon. In the context of perspective, the *true* horizon is simply a horizontal line at our eye level (eye level line). At sea or on a dead level plain the horizon we see is the true horizon. However, hills, trees and buildings often obscure the true horizon, so we have to gauge where it should be. This is not as difficult as it may sound. The sketch above should make matters clear. The position of our eye level line is indicated by the stretch of sea. To find the true horizon, this line,

which is indicated by the dotted line, is extended across the hills to the trees beyond. For simplicity I use the term 'eye level line' instead of 'true horizon' throughout this book.

You may place your eye level line high or low on your paper, according to the demands of the subject. However, you must remember that objects above that line are above your eye level, and, conversely, that objects below it are below your eye level.

Simple constructions

The concept of perspective is based upon the fact that objects appear to get smaller the further away they are – a fact we can readily verify ourselves.

Figure 1 shows a row of vertical posts, all in line and all of equal height. As you can see, the posts become ever smaller until they disappear altogether, at what is called the vanishing point (VP). If our line of poles is on a dead level surface, this vanishing point will be on our eye level line.

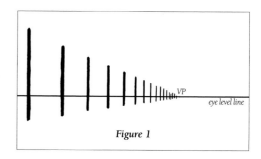

Figure 1

Figure 2 shows what happens if we now draw a line through the tops of the posts and another through the points where they enter the ground. These lines will be straight and will meet at the vanishing point (VP).

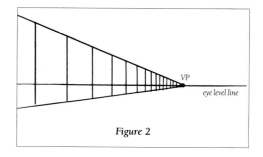

Figure 2

In Figure 3, if the posts are evenly spaced, the gaps between them may be found by drawing the line through their mid-points to the VP, joining the top of the first post to the mid-point of the next and extending it to meet the ground line. This will give you the interval to the third post.

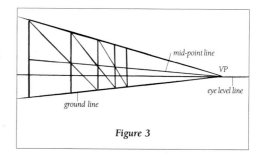

Figure 3

So far we have considered just one vanishing point. Figure 4 shows what happens if we now look at a solid rectangular object, such as a hut. Each of the sides we can see has its own vanishing point, and we now have the simple construction with which we can check the perspective of any solid rectangular figure. Having drawn our hut, we extend the lines forming the tops and bottoms of the visible sides until they meet, and if our drawing is accurate, they will meet at two vanishing points on our eye level line. Of course many buildings are far more complex in shape than this, but they can all be simplified into separate rectangular forms which can then be dealt with individually. This is demonstrated on pages 10 and 11. It is clear from Figure 4 that lines above the eye level line slope down from the nearest corner of the hut and that lines below the eye level line slope up.

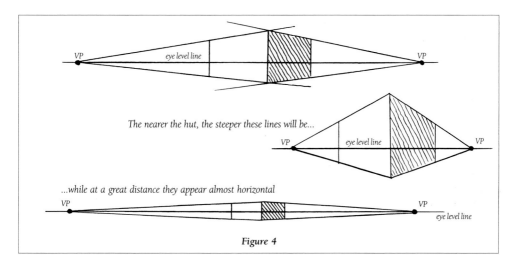

The nearer the hut, the steeper these lines will be...

...while at a great distance they appear almost horizontal

Figure 4

Finally, Figure 5 shows the construction of solid rectangles wholly above and wholly below the eye level line.

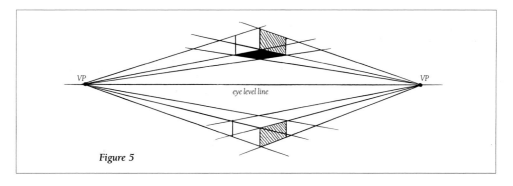

Figure 5

Further constructions

So far we have considered the perspective of simple box-shaped objects and we now have to face the fact that real life is rarely so straightforward. Even our basic hut will have a roof and we must know how to draw it accurately.

Figure 1 shows the two visible walls of the hut drawn in heavy lines. If we now draw a perpendicular through the intersection of the diagonals of the end wall, we know that the nearer end of the roof ridge will be on that line. You will also notice that this perpendicular is not quite in the centre of its wall, but slightly nearer the right hand corner, thus allowing for the fact that the nearer half of the wall naturally appears larger than the more distant half. We mark the height of the gable on the perpendicular and join that point to the top corners of the end wall to establish the sloping lines of the roof. We now draw a straight line from the same point to the left hand vanishing point to give us the top ridge of the roof.

The far slope of the roof is roughly parallel to the nearer slope we have already drawn. However, because the top ridge of the roof is slightly more distant than the lower margin of the roof, these slopes will not be exactly parallel, as the construction in Figure 2 makes clear.

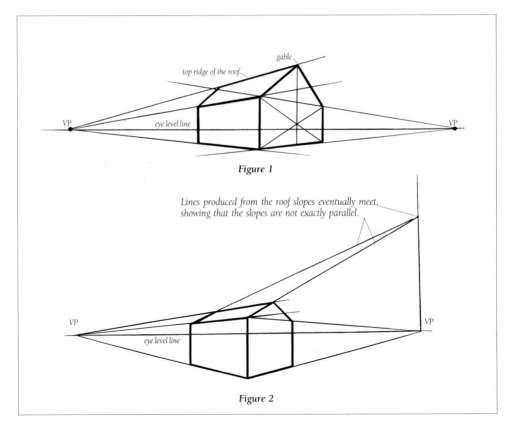

Figure 1

Figure 2

Figure 3 shows a more complex shape than our simple hut. Here I have drawn a house with a couple of additions and you will see how each has been treated as a simple solid rectangle to establish its perspective. Even the chimney comes in for the same treatment, as do the doors and windows. As long as all the extra bits are at right angles to or parallel with the main block, all will be well and this perspective construction will work.

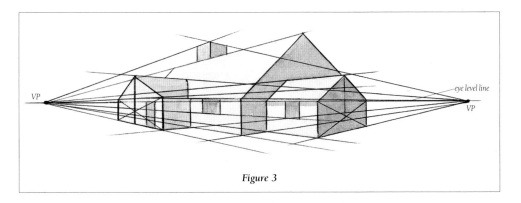

Figure 3

In Figure 4 we learn how to draw objects which are at different angles to each other, like this row of terraced houses built following a curve in the road. The thing to remember here is that each house will have different vanishing points. You can see that the oblique angled houses have near vanishing points, but the more the houses swing round to face us, the more remote their vanishing points become. When a house is facing us head on, the lines forming the top and bottom of the front wall will be exactly parallel and so will never meet.

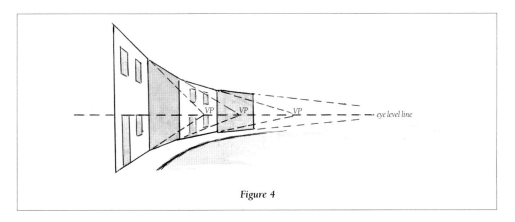

Figure 4

Shadows

The experienced artist usually paints shadows from observation alone, and when they fall across rough or uneven ground, any slight inaccuracy is barely noticeable. However, knowledge of the perspective construction of shadows is a useful safeguard against gross error. With the less experienced, problems are naturally more likely to arise and we have all seen paintings in which the shadows appear to be coming from a variety of directions. This fault usually arises from poor observation rather than ignorance of perspective and often occurs when a painting has taken so long to complete that the position of the sun has shifted appreciably!

Another common fault is that of painting shadows in the field as though they were falling across a completely flat surface rather than over rough ground – again a failure of observation.

Figure 1 shows that, if observed accurately, shadows perform the useful function of helping to describe the surface over which they fall.

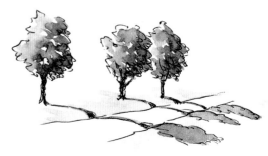

Figure 1

The perspective construction of shadows is complicated by the need to consider the direction of the light source – in landscape work, the sun – and the point on the eye level line which appears to be vertically below that light source.

Figure 2 shows the perspective of the shadow cast by a solid rectangular building, and if you study this carefully, you will see how it all works.

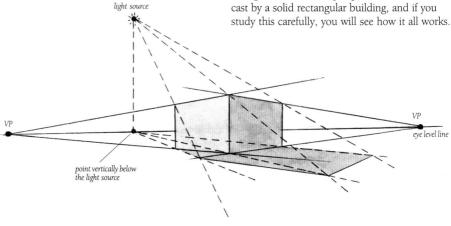

Figure 2

12

Because of its great distance, the shadows cast by the sun are parallel, but the effect of perspective often makes them appear to radiate. This occurs when one is looking, for example, into a copse with the sun behind it, or observing people in a sunlit street, again, with the light behind them.

Figure 3 deals with this situation and explains both the direction and length of the cast shadows.

eye level line

Figure 3

Figure 4 shows what happens when the light is coming from exactly one side: the shadows are parallel.

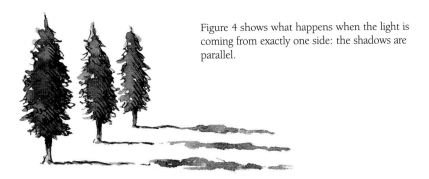

Figure 4

13

Exercise 1

The time has come to put into practice the perspective theory we have covered so far and to put our mastery of it to the test. Let us begin by making three quick colour sketches of simple buildings, one on the eye level line, one above it and one below it (right).

The perspective looks about right but let us now check it. I have repeated the sketches in paler tones so that the perspective construction lines will show up more clearly.

Now it is your turn! Do not worry if your freehand sketches have faults – you can now check for error and accuracy.

Quick colour sketches

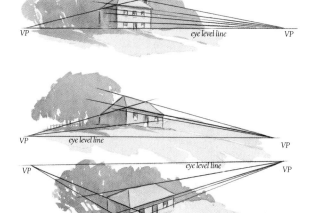

Perspective lines

As usual, we start by putting in the eye level line and we must take good care to get this right. We now plot our first pair of perspective lines, and here I chose the lower margins of the roof. Where these lines cut the eye level line gives us our two vanishing points. We now add further perspective lines, for the roof ridge and the tops and bottoms of the windows. If our original drawings were accurate, these lines will confirm it; if not, discrepancies will show up! Here we were reasonably accurate, but it is useful to have our accuracy confirmed.

Problems sometimes arise when buildings are situated on steeply sloping roads, so in our next task we will tackle an attractive lane leading down to the sea. Although the scene may appear to be a daunting one, we will not go far wrong if we apply the basic perspective constructions. Here, then, is our sketch of such a scene; for the sake of simplicity I have assumed that the buildings, however quaint, are all in the same straight line or, in other words, all parallel.

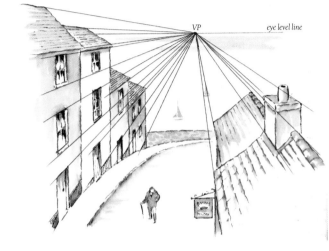

Now we draw in our red perspective lines. We begin with the eye level line which, conveniently, is the sea horizon. Because the buildings are all parallel, they have a common vanishing point from which the perspective lines radiate. You will see how the construction of the buildings adapts to the steeply sloping road.

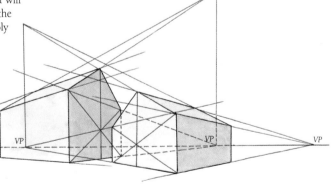

Buildings at different angles will have different vanishing points, though still, of course, on the eye level line. In the above sketch I have included just two buildings, again for the sake of simplicity, but it is easy to see how more, at varying angles, could be added. The addition of the red perspective lines clearly shows the two separate sets of vanishing points.

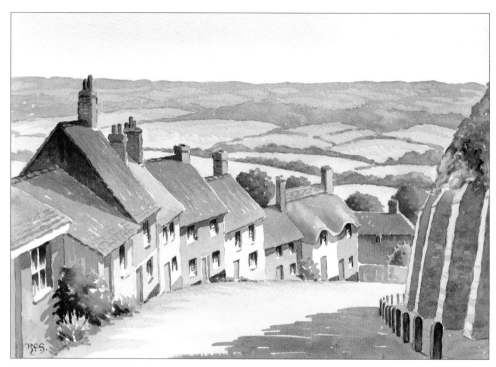

Shaftesbury, Dorset
365 x 250mm (14 x 10in)

In this well-known scene, the cottages lining the steeply sloping road are all below the eye level line, but unlike the buildings in the diagram on page 15, they are not all parallel and so have different vanishing points. If you extend the lines forming the upper and lower margins of the roofs, you will find that they meet at various vanishing points on the eye level line (making due allowance for the sometimes wayward lines of old buildings!)

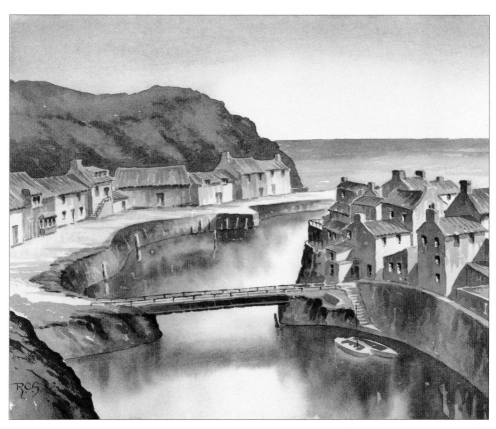

Staithes, Yorkshire
360 x 290mm (14¼ x 11½in)

In this attractive vista, all the buildings are, again, below the eye level line, and so their perspective lines slope upward to meet at various vanishing points on the eye level line, which is given to us by the sea horizon. Because many of the buildings are at different angles, there will be a corresponding number of different vanishing points.

Ellipses and curves

The perspective of circles

Many everyday man-made objects are wholly or
partly circular in shape – plates, cups, bowls,
glasses, wheels, the list is endless – so we have to
know how to draw circles in perspective.

Figure 1 shows that a circle fits snugly into a
square. You will see that the circle actually touches
each of the four sides of the square – in geometrical
terms the sides of the square form tangents with
the circle.

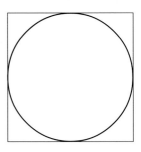

Figure 1

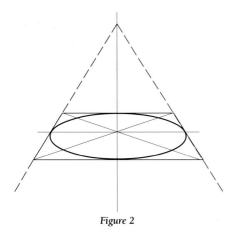

Figure 2

Figure 2: we know how to draw a square in
perspective so will have little difficulty inserting a
foreshortened circle (or ellipse) within it.

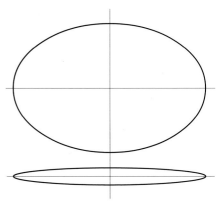

Figure 3 shows how the shape of the ellipse can
be anything from a slightly flattened circle to little
more than a straight line, with an infinite number
of variations in between. The shape depends on the
angle of the ellipse's surrounding square.

Figure 3

As Figure 4 makes clear, an important thing to remember is that a circle has no corners and the same naturally applies to a foreshortened circle, or ellipse. The curve at each extremity may become very tight, but it is still a curve and not a point.

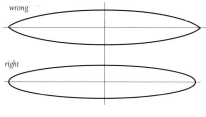

Figure 4

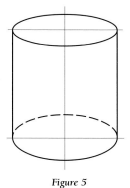

Figure 5

Figure 5 shows what happens when you draw a flower vase in the shape of a cylinder. The top ellipse and the bottom ellipse (only half of which is visible) will not be the same shape. The ellipse further from the eye level line will always be fuller than that nearer the eye level line.

Curvilinear objects

Some other objects containing subtle curves are difficult to draw, and here perspective constructions may well come to our aid. Boats are a case in point, and artists frequently have difficulty making them look at all seaworthy.

Figure 6 shows that a boat fits comfortably into a coffin-shaped box, which is of course amenable to perspective constructions, and many find this makes their job easier.

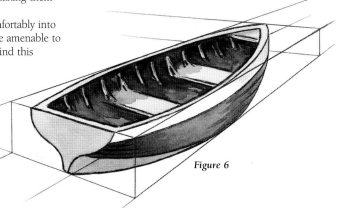

Figure 6

Exercise 2

Perfect circles and ellipses seldom feature in landscape work, but we have to be prepared for the occasional cart or tractor wheel. In still-life subjects we are very likely to meet vases, bowls, jugs, bottles and glasses, so a knowledge of the geometry involved is essential.

Figure 1 shows an ellipse enclosed within a square, drawn in perspective. If we draw a line parallel to the horizontal sides of the square, through the point where the diagonals intersect, we find the points where the extremities of the ellipse touch the other two sides of the foreshortened square. The ellipse touches the other two sides of the square at their mid-points.

Now practise this construction for yourself. Begin with the geometric construction and draw the ellipse within the foreshortened square. Then draw the ellipse freehand and check your accuracy by constructing the geometric framework around it.

If you repeat the process with fuller and narrower ellipses, you will be well on the way to mastering the problem, but be sure to avoid giving your ellipses pointed extremities!

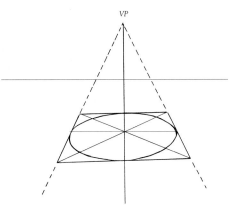

Figure 1

Figure 2 shows a cylindrical vase enclosed within a cube. You will see immediately why the lower ellipse is fuller than the upper, which is closer to the eye level line.

Construct the perspective framework and draw the vase within it. Now reverse the order, drawing your vase freehand and construct the geometric framework around it. How accurate was your freehand drawing?

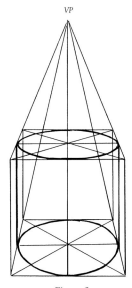

Figure 2

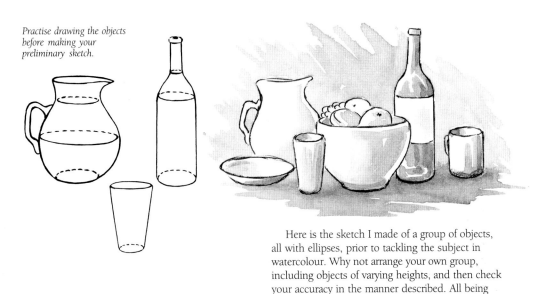

Practise drawing the objects before making your preliminary sketch.

Here is the sketch I made of a group of objects, all with ellipses, prior to tackling the subject in watercolour. Why not arrange your own group, including objects of varying heights, and then check your accuracy in the manner described. All being well, you can go on to make a still-life painting of your own.

Still-life
270 x 135mm (10¾ x 5½in)

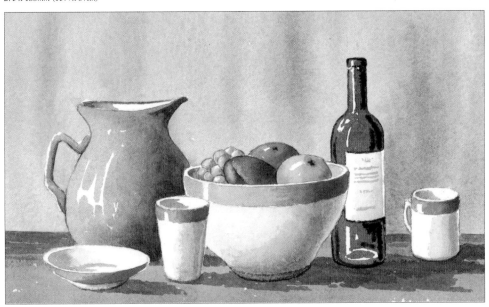

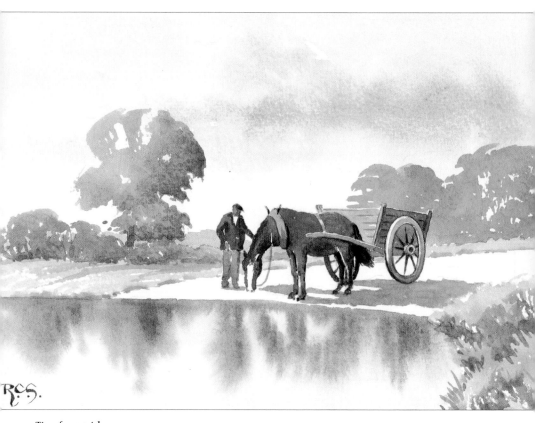

Time for a quick one

285 x 190mm (11¼ x 7½in)

Landscape subjects do not often contain ellipses, but here the large cartwheel provides an opportunity to put our knowledge to the test.

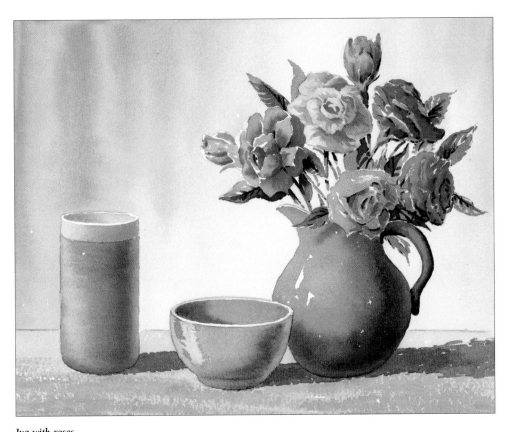

Jug with roses
310 x 250mm (12¼ x 10in)

There are several ellipses and half ellipses in this simple still-life composition, and you will notice that they become progressively deeper the further they are below the eye level line.

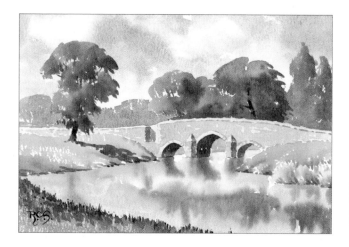

Fittleworth Bridge
350 x 240mm (13 ¼ x 9½in)
A watercolour sketch showing soft-edged reflections.

Reflections

Simple reflections

Many people assume that an object reflected in still water produces a mirror image or, in other words, that the reflection will be an exact upside-down version of the object. Indeed, this is often the case, but not always!

Figure 1 shows a vertical pole sticking up out of the water: here the length of the reflection will be exactly the same as that of the pole. This will be true even if the pole is leaning to one side, as the second one is.

Figure 1

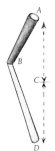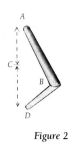

Figure 2

However, Figure 2 demonstrates that when the pole is leaning towards us or away from us, the size of the reflection varies. First, we find the point on the water's surface vertically under the top of our pole AB – this point is C. We now extend AC vertically down to point D, so that the length of CD is equal to that of AC. If we now join the base of the pole, B, to point D, we have our reflection, BD. You will see at once that when the pole is leaning towards us, its reflection is longer than the pole, and when it is leaning away from us, its reflection is shorter.

24

Complex reflections

If a building, for instance a tower, is situated right on the water's edge, the whole of it will be reflected, as in Figure 3.

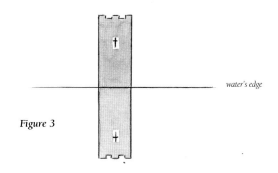

water's edge

Figure 3

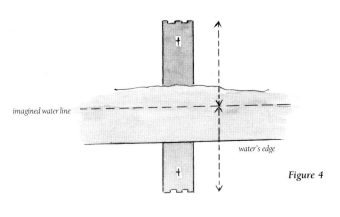

imagined water line

water's edge

Figure 4

In Figure 4, a problem arises. Here the tower does not stand directly on the water's edge, but some way back. What we have to do here is to imagine the plane of the water's surface cutting horizontally through the river bank to a position vertically under the tower: this is shown by the dotted line. If we measure the distance from the top of the tower to this line, and extend it vertically downwards an equal distance, we will find our reflection.

Figure 5 shows the view from the side and explains why only a part of the tower reflection is visible, with the position of the river bank cutting off the reflection of all but the upper two-thirds of the tower.

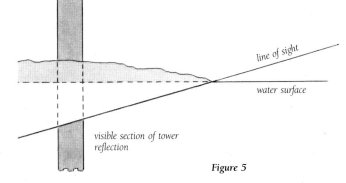

line of sight

water surface

visible section of tower reflection

Figure 5

Hard-edged reflections

When the surface of the water is disturbed by a slight breeze, rippling occurs, and this naturally modifies the reflections. These become indented and have to be painted so as to suggest the rippling effect. Always remember that ripples, too, are subject to the laws of perspective, so make the nearer ones larger than the more distant ones! The watercolour sketch below shows this effect, with the ripples decreasing in size as they recede into the distance. Simplify the scene if necessary and avoid painting too many ripples, which could over-complicate your picture.

Those with experience in painting water will know that reflections vary with the type and strength of the breeze. In some conditions the effect is to produce masses of tiny ripples, so small that only the most precise painting style could represent them literally, and here those with looser styles will have to seek other solutions. If they look at a mass of ripples through half-closed eyes, detail is lost and the surface resolves itself into soft-edged areas of tone and colour which such techniques as watercolour wet-in-wet will capture effectively. In certain weather conditions, nature herself may oblige by producing these soft-edged reflections, as seen opposite.

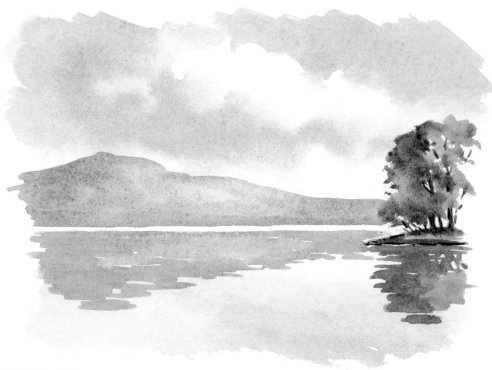

Hard-edged reflections.

Soft-edged reflections

The artist is sometimes faced with problems posed by a fairly complex scene with a perfect mirror image reflected in the water below. If painted literally, the result will become too busy, with the reflections competing with the scene above rather than complementing it, and the eye finding no calm passage where it can come to rest. In such situations it pays to exercise a little artistic licence and make the reflections soft-edged. The painting below is an example of this sort of treatment.

Soft-edged reflections are naturally less precise than mirror images and so do not demand the same rigorous application of the laws of perspective. At the same time, a knowledge of those laws is a safeguard against gross error.

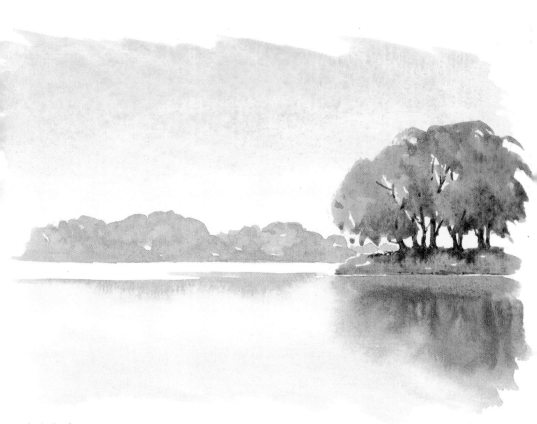

Soft-edged reflections.

Exercise 3

The presence of water in the landscape can enliven the dullest scene and provide much needed light and sparkle, but before we can do it full justice, we have to know how to deal with reflections. Careful observation is the obvious starting point but a knowledge of the perspective of reflections is an essential safeguard against error.

As we have seen, objects situated on the water's edge present no problem – in still water they produce precise, inverted mirror images, as in the sketches below.

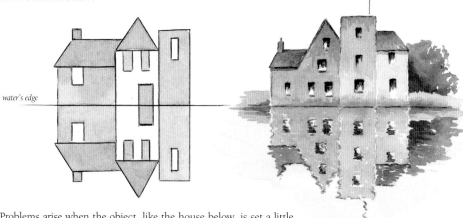

Problems arise when the object, like the house below, is set a little back from the water's edge, perhaps on a slight incline so that its base is three metres (ten feet) above the water level. We then have to imagine the water surface extending in the same plane to the base of the house. It then becomes clear that the reflection would be as shown in the sketch below, but the only part visible would be that below the water's edge line.

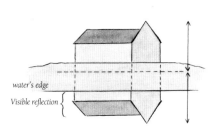

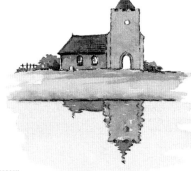

Try out these two constructions for yourself, to confirm your understanding of the rules.

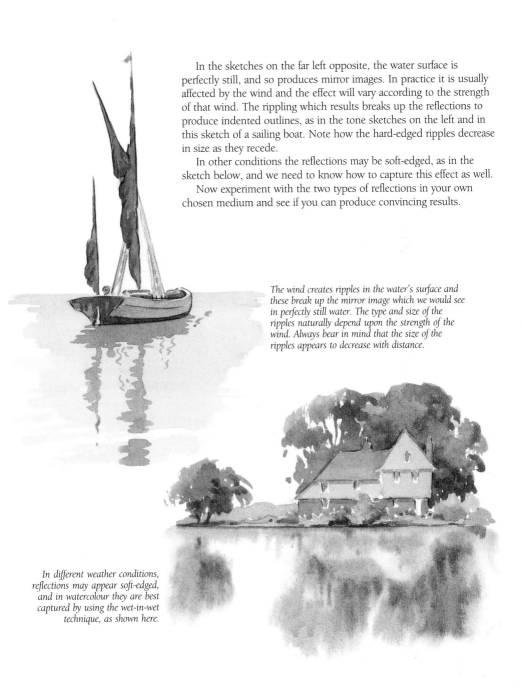

In the sketches on the far left opposite, the water surface is perfectly still, and so produces mirror images. In practice it is usually affected by the wind and the effect will vary according to the strength of that wind. The rippling which results breaks up the reflections to produce indented outlines, as in the tone sketches on the left and in this sketch of a sailing boat. Note how the hard-edged ripples decrease in size as they recede.

In other conditions the reflections may be soft-edged, as in the sketch below, and we need to know how to capture this effect as well.

Now experiment with the two types of reflections in your own chosen medium and see if you can produce convincing results.

The wind creates ripples in the water's surface and these break up the mirror image which we would see in perfectly still water. The type and size of the ripples naturally depend upon the strength of the wind. Always bear in mind that the size of the ripples appears to decrease with distance.

In different weather conditions, reflections may appear soft-edged, and in watercolour they are best captured by using the wet-in-wet technique, as shown here.

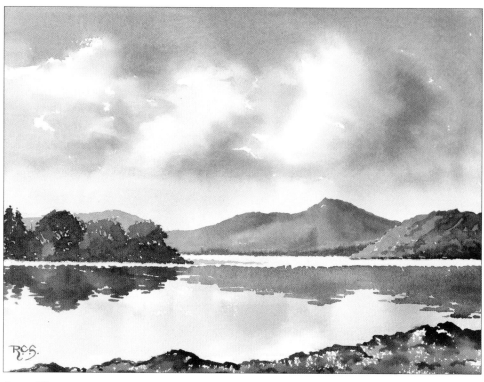

Causey Pike
390 x 285mm (15¼ x 11¼in)

In this lakeland scene, the distant mountains and the wooded island are reflected in the gently rippling surface to give rise to horizontally indented outlines. We have already noted that ripples appear to decrease in size as they recede. Stronger winds produce steep-sided ripples which reflect the sky above rather than the scene beyond and so produced areas of pale water. The strip of pale water in this painting was caused in this way.

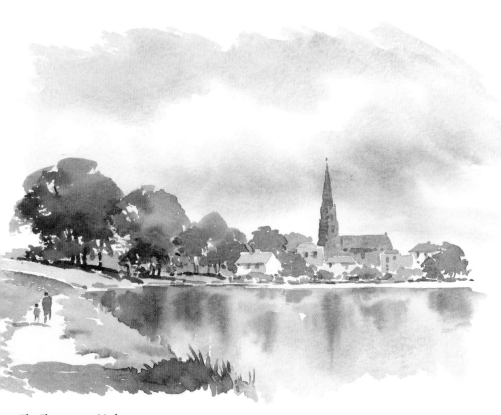

The Thames near Marlow
310 x 220mm (12¼ x 8¾in)

*Here is another example of soft-edged reflections. As the subject is fairly complex,
the soft treatment of the reflections provides useful contrast. Note the thin strip of
pale, disturbed water, which conveniently separates the reflections from the scene
above. The two small figures on the left help to provide scale, while the deep shadows
in the foreground make the water shine by contrast.*

Aerial perspective

Introducing aerial perspective

The atmosphere around us is rarely completely clear, as water vapour, smoke and dust all play their part in creating misty conditions. Even on comparatively clear days, the effect is noticeable and the far horizon appears a pale misty blue/grey. Naturally, the weather has a vital role and the density of the mist increases roughly in line with humidity. This effect is known as aerial perspective and its results are threefold:

Contrast The strong tonal contrasts of the foreground are progressively reduced with distance so that a far range of hills may be accurately rendered by a flat blue/grey wash.

Tone Colours become increasingly pale with distance.

Colour The warm colours of the foreground are replaced by cool – mainly soft blues and greys.

The Farm Gate
250 x 165mm (10 x 6½in)

The warm colours and strong tones of the foreground contrast with the soft, cool treatment of the distance to produce a convincing feeling of recession.

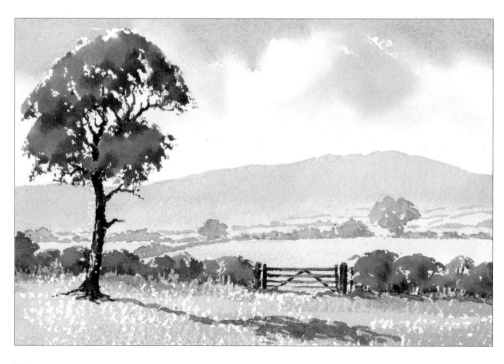

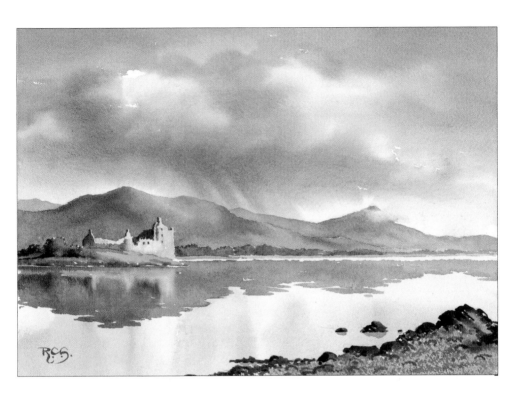

In addition, outlines become less sharp, as shown in these paintings, and distant features may appear soft-edged, or disappear altogether.

Aerial perspective greatly strengthens the effects of linear perspective and diminishing scale in creating a feeling of recession and depth. It is achieved by a sensitive use of tone and colour.

There are, of course, very clear days from time to time, when the horizon appears as crystal clear as the foreground and there is little or no colour change in the distant scene. If we were to record such conditions literally, our paintings would lack any feeling of depth and would look unconvincing. This, therefore, is another occasion on which we would do well to exercise a little artistic licence to achieve a more atmospheric and effective result.

When there is a lot of smoke in the atmosphere combined with high humidity, fog usually results

Kilchurn Castle, Loch Awe
380 x 285mm (15 x 11¼in)

Deep tones were needed for the lowering clouds, the hills and their reflections, so even stronger tones were required for the foreground rocks, to preserve the feeling of recession.

and takes on a yellowish brown hue. The 'London Special', before the days of the smokeless zone, was, perhaps, the most notorious of all fogs and was graphically recorded by a number of Victorian artists. Today we are more concerned with misty conditions.

Of all the media, watercolour is supreme in conveying, freshly and economically, the atmosphere of misty landscapes and the wet-in-wet technique, in skilled hands, can capture the mystery of soft outlines to perfection. It is a technique well worth practising.

33

The use of tone and colour

One of the most important objectives of the landscape painter is to give his or her work a genuine feeling of depth, and when successful, the paintings attract the comment, 'I could really walk into that!' This happy state of affairs does not just happen, but is the result of a deep understanding and appreciation of aerial perspective. Let us now go more fully into its implications.

We know that tonal contrast decreases with distance, but how do we achieve this effect? It helps us to have an object in the foreground with both light and dark tones to which we can do full justice. This could be a whitewashed cottage with dark exposed beams or even a building with strong tonal differences between its sunlit and shadowed elevations. We must then ensure that the difference between the lights and darks of the middle distance is less, and lesser still in the far distance. Naturally

the amount of mist in the atmosphere affects the extent to which tonal contrast decreases – on misty days, the decrease is rapid, on clearer days, much less so.

We have seen that tone also decreases with distance and we should try to place at least one deep-toned object, such as a dark tree trunk, in the foreground, and then ensure that nothing in the middle distance and still less in the far distance, approaches it for tonal depth. Most painters work from the top downwards, which in practice means starting with the sky, then painting the far distance,

Wealden Farmhouse
250 x 165mm (10 x 6½in)
The warm colours of the foreground ploughland and autumnal foliage contrast with the cool colours of the distant hills to create a strong feeling of recession.

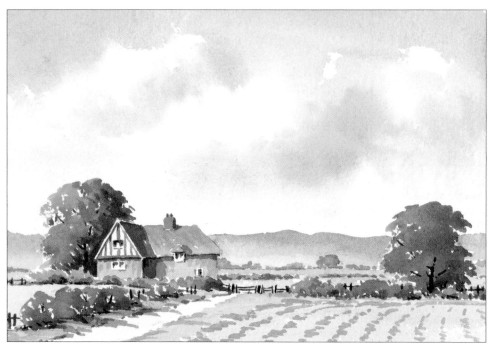

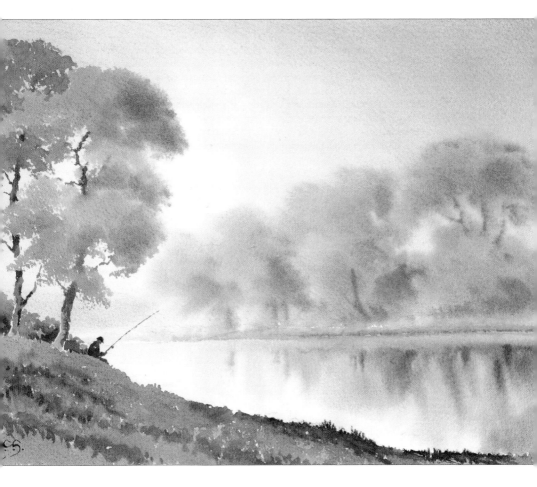

then the middle distance, and ending up with the foreground. This sequence helps if we remember to increase progressively the strength of our washes.

The 'blue remembered hills' remind us that cool blues and greys have their place in the distance, as shown in the painting opposite. We know too that warm colours – the reds, oranges and yellows – 'come forward'. This is fine when we have red brick buildings or warm brown ploughland in the foreground, but what about grass? Foreground grass contains a lot of yellow (a warm colour) so all is well!

Misty River
385 x 290mm (15¼ x 11½in)

In this painting, tone decreases with distance or, in other words, the colours become paler as they recede. In addition the outlines of the more distant trees are softer and more misty than those in the foreground, though even here there is a little softness in places to suggest the movement of foliage.

Creating depth

We have already noted the importance of creating a feeling of depth, to carry the eye right into the heart of our paintings, and have considered some of the ways in which this may be achieved. We have seen how linear perspective may be graphically reinforced by aerial perspective, so that tonal contrast and tonal weight diminish with distance and warm colours give way to cool. Let us now see whether there is any more we can do.

The thoughtful placement of the objects in our composition is a good starting point, and if we arrange them so that they overlap, the diminishing size, paler treatment and cooler colour of the more distant objects immediately suggest depth.

Buildings, trees, hills and so on may all be used in this way. The careful drawing of rivers, streams, roads and tracks may be used to good effect, to carry the eye from the foreground into the middle or far distance. The lines of receding fences and hedges can also play their part.

Winter Woodland
240 x 160mm (9½ x 6¼in)

In this painting I have used two techniques to achieve a feeling of depth, in addition to the obvious one of decreasing the size of the trees as they recede. Firstly, I made the foreground trees dark and lightened my tones towards the background. Secondly, I used strong, warm colour in the foreground and pale, cooler colour in the background.

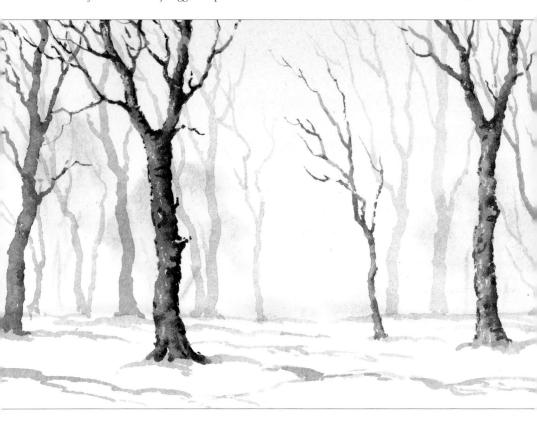

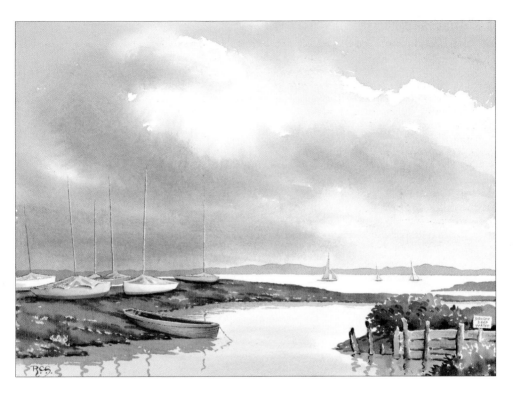

The outlines of foreground objects are naturally more clear cut and stronger than those of similar objects at a greater distance, and this difference may be suggested by varying the clarity and strength of our edges – bold and firm in the foreground, soft and pale in the distance, with suitable gradations in between. In the painting opposite, this technique is used to make the trees in a stretch of winter woodland recede into the distance.

The Hard, Brancaster Staithe
390 x 285mm (15¼ x 11¼in)

Here there is plenty of tonal contrast in the foreground but virtually none in the line of distant sandhills. The foreground colours, though mainly dark, are basically warm, while the distant colours are very cool. Both these factors help to create a feeling of depth and recession.

Exercise 4

As we have seen, aerial perspective greatly enhances the impression of depth and recession created by linear perspective and we should take full advantage of its subtle but telling effects. These are threefold and are worth repeating.

Tonal contrast

This simply means the difference between lights and darks. This contrast is greatest in the foreground and gradually decreases to the far distance, as the sketch below indicates. If you compare the difference in tone between the light and shade in the foreground with that of the distant hills, you will see what I mean.

Cumblerland Hills
260 x 185mm (10¼ x 7¼in)

As we have seen, there is strong tonal contrast between the pale foreground grass and the deep tones of the trees, hedges and fences and their shadows, while there is virtually none in the line of distant hills.

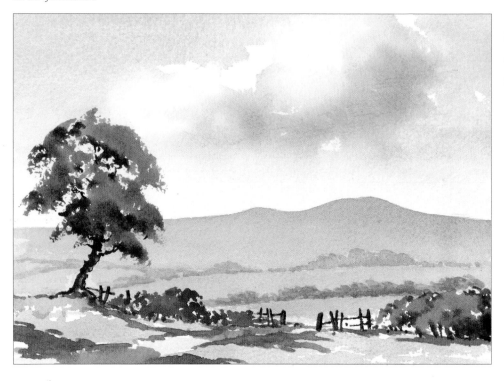

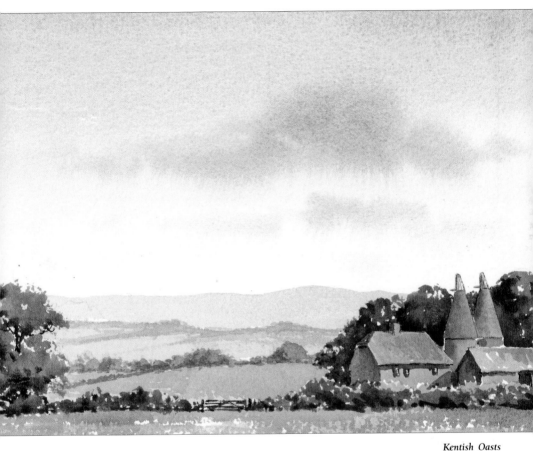

Kentish Oasts
260 x 185mm (10¼ x 7¼in)

In this painting you will notice how the deep tones are all in the foreground, and how the depth of tone gradually decreases towards the distance, with the far hills the palest of all.

Tone

In general terms colours become paler with distance. There are, of course, exceptions, such as a sunlit white-washed cottage in the foreground, but even this will be balanced by the deep tones of its cast shadow.

As you can see in the above sketch, the overall tones of the foreground, the middle distance and the far distance decrease from front to back.

In these two paintings you have seen how tone and tonal contrast may be used to convey a powerful feeling of recession and depth.

Now it is your turn! Make a quick sketch in your chosen medium and see how effectively you can make the foreground come forward and the background recede.

Colour

Mist has the effect of filtering out warm colours – the reds, yellows and oranges – leaving just the cool blues and greys. It follows therefore that the greater the depth of misty atmosphere, the greater this effect will be.

Grass green is made up of yellow (a warm colour) and blue (a cool colour). Foreground grass contains more of the former and so is a warm green, while distant grassy fields contain more of the latter and so are a cool green, or even a blue.

It is a very common fault to make foreground foliage greens too blue, often the result of using some made-up greens uncritically. It always pays to give full value to the tinges of yellow, orange and brown that are often there.

In the painting below, I have given full rein to these three effects of aerial perspective, with tonal contrast and tone itself decreasing and colours becoming ever cooler with distance.

The Distant Downs
260 x 185mm (10¼ x 7¼in)

Colour plays an important part in creating aerial perspective. In this painting the warm browns and greens are in the foreground and the colour temperature drops progressively towards the cool colours of the far hills.

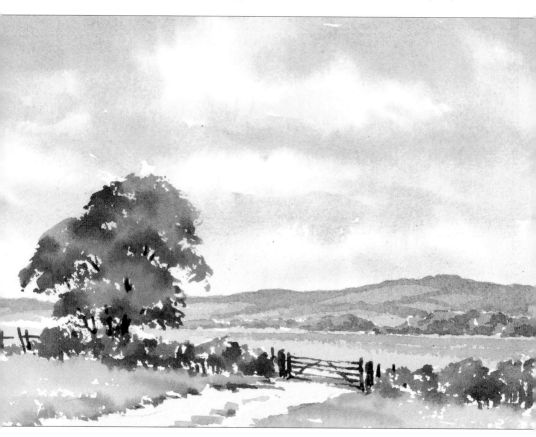

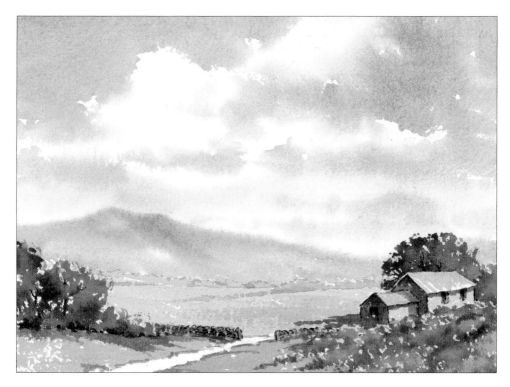

Some atmospheric conditions blur the outlines of distant objects, so hard edges become soft. This effect can best be captured in watercolour by the wet-in-wet technique. In the above sketch you will see how the soft outline of the distant hills contrasts with the crisper treatment of foreground objects. This is a technique well worth cultivating if you wish to produce subtle paintings rich in atmosphere.

Why not have a go yourself and make a painting in which you, too, emphasise the influence of aerial perspective? Remember to use the effects of tonal contrast, tone, colour and soft and hard edges to create depth.

In Wester Ross
260 x 185mm (10¼ x 7¼in)

In this painting we will consider all three of the principal factors which contribute to aerial perspective – tonal contrast, tone and colour. There are strong differences between the foreground lights and darks, with far less contrast in the distant hills. In the same way, tone itself lightens from front to back, with all the darks in the foreground. Finally colour – here the warm browns and greens are all in the foreground, and the colours gradually become cooler as they recede, with the distant hills mirroring the cool blue greys of the clouds.

Final thoughts

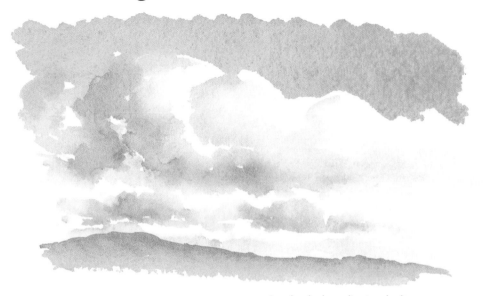

Cumulus clouds receding into the distance.

The perspective of natural objects

We usually think of perspective in connection with objects such as buildings, with basically rectangular shapes, and it is true that these are amenable to precise geometric constructions in a way that most natural objects are not. However, the basic perspective rule that all objects appear to decrease in size as they recede holds good whatever their form and nature. Most artists recognise this, but while they make sure that their hills, trees and rivers become ever smaller with distance, they sometimes fail to give similar attention to their clouds. In squally conditions, clouds may seem to lack form and shape, but in calmer conditions more consistent patterns often emerge.

Think of a sky filled with cumulus clouds. These usually have high, domed crests with comparatively level bases, and produce a fairly regular pattern as they recede into the distance – the sketch above suggests a suitable treatment. Whatever type of cloud formations you encounter, you will create an impression of depth if you ensure your clouds decrease in size with distance.

Opposite
Bend in the River
380 x 280mm (15 x 11in)
An example of a river scene where careful observation alone must ensure the water surface lies flat!

42

The straight-sided canal helps us to draw the river.

The less experienced often have difficulty with rivers and sometimes make them appear to be flowing uphill! Unlike straight-sided canals, there is no geometric construction to help and we have to rely on careful observation alone. It sometimes helps to construct a straight-sided canal roughly parallel to your river on your preliminary sketch, as I have done in the above sketch.

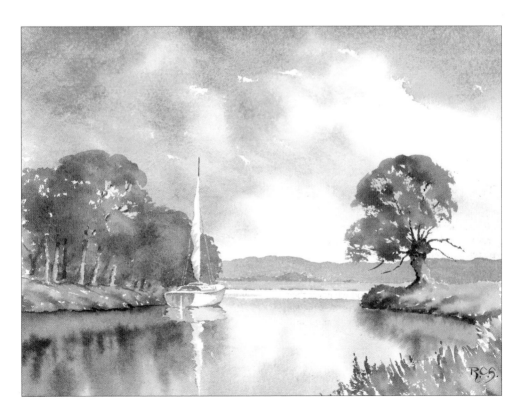

Stretching the rules

In our determination to get the perspective of our paintings right, it is all too easy to overlook the possibilities presented by unconventional or even dramatic compositions. This is a danger we must guard against.

We should be constantly on the look-out for arrangements that will distinguish our work from the run of the mill and give it punch and originality. One of the ways we can do this is to adopt an unusual viewpoint, as in the quick sketch below.

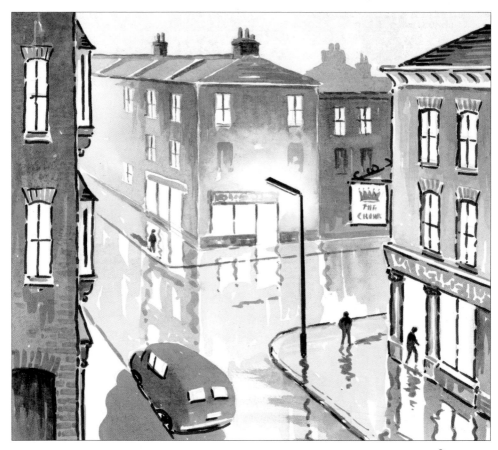

Street corner
185 x 180mm (7¼ x 7in)
The high viewpoint of this quick sepia impression adds a little interest to a mundane scene. Unusual angles sometimes pose perspective difficulties but once the position of the eye level line is determined, the familiar perspective constructions soon solve the problem.

This not only creates a more striking image, it also emphasises some features of our subject. A high viewpoint helps us capture the pattern of jumbled roofs which may be hidden from ground level. Adopting a worm's eye view may enable us to say more about the impact of high-rise buildings or forest giants than a more conventional approach could. The possibilities are endless. The answer is to look at our chosen subject from all angles and not, in our haste to get painting, to settle for the first reasonable composition that presents itself.

So far, we have been concerned with the correct application of the rules of perspective. I am now going to suggest that it is sometimes permissible to vary them or even do violence to them. I am certainly not advocating breaking them for the hell of it or, as some would-be trendy painters do, simply to shock, but there are occasions when, by stretching the rules, we can emphasise some feature of our subject – perhaps its height or its dramatic outline. I once saw an exhibition featuring the New York sky-line in which most of the laws of perspective had been ignored, but the artist certainly achieved a vivid impression of the vast, looming forms of the skyscrapers, and his rule-breaking was fully justified.

At the other extreme we appear to break the rules when we depict the wayward lines of old buildings, though here it is the buildings themselves that depart from the precision of modern architecture, and we are simply recording what is there. If we exaggerate their eccentricities a little to emphasise their venerable character, well and good.

We should always be on the look-out for ways of giving our paintings depth, in addition to the obvious one of making our objects become smaller as they recede. As we have seen, the answer lies in aerial perspective, with our nearer objects painted crisply in warm colours with plenty of tonal contrast, and our distance painted more softly in cool colours with little or no tonal contrast.

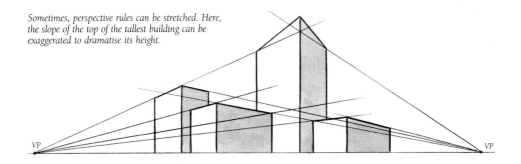

Sometimes, perspective rules can be stretched. Here, the slope of the top of the tallest building can be exaggerated to dramatise its height.

VP

VP

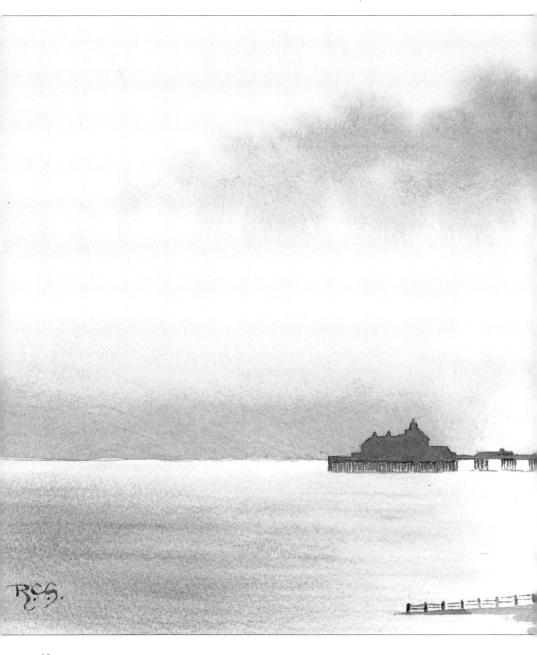

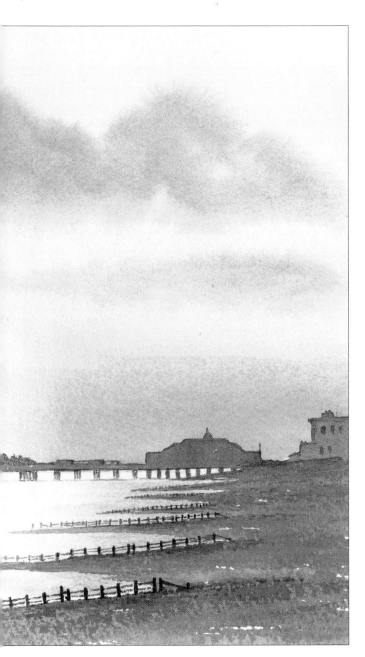

Eastbourne Pier, Evening
390 x 240mm (15¼ x 9½in)

*Aerial perspective theory suggests
that the tone of the pier might
have been rather lighter than I
have made it, but I feel that strict
adherence to theory would, in this
instance, have lessened the impact
of the painting. We all break the
rules sometimes, but we should
have a good reason for doing so!*

Index

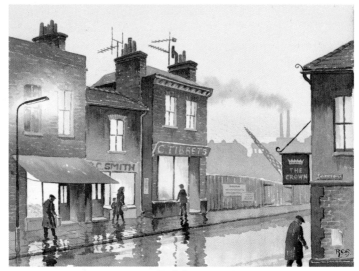

Back Street
380 x 280mm (15 x 11in)